MARY CASSATT

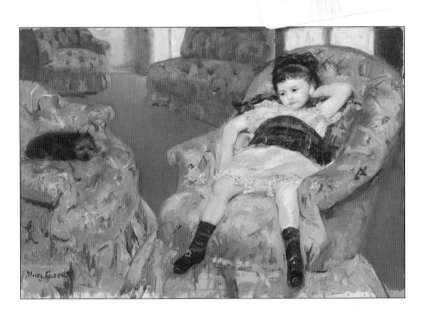

T&J

Published by TAJ Books International LLC 2013
5501 Kincross Lane
Charlotte, North Carolina, USA
28277

www.tajbooks.com
www.tajminibooks.com

All notations of errors or omissions (author inquiries, permissions) concerning the content of this book should be addressed to info@tajbooks.com.

ISBN 978-1-84406-240-9
978-1-62732-010-8 Paperback

Printed in China

2 3 4 5 17 16 15 14

MARY CASSATT

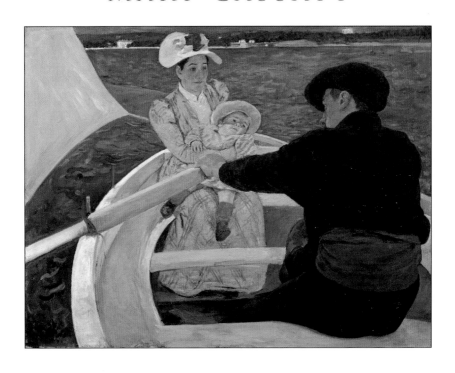

T&J

KATHRYN DIXON

MARY CASSATT

1844–1926

Although Mary Stevenson Cassatt never married, having decided early in life that marriage would be incompatible with her career, and did not have children of her own, she is best known today for her paintings, pastels, and prints of mothers and their children. During the late 1870s and early 1880s, as her career was taking flight, the subjects of her works were often her family—especially her sister Lydia—engaged in the mundane tasks and simple pleasures of daily living, as well as the themes of the theater and the opera. Seeking a new form of expression after her sojourn with the Impressionists, Cassatt experimented with new techniques and entered her most productive years in the decade of the 1890s. Her focus shifted in the later years of her career, after 1900, to the portrayal of the intimate bond between a mother and child.

A great friend of Edward Degas, the noted Impressionist painter, Cassatt was influenced by his techniques and methods, and was the only American to be a member of the Impressionist movement during its productive years. Her prodigious body of work—over 400 known paintings, pastels, and prints—is exhibited in museums throughout the United States as well as in museums in Canada,

France, and Russia, and is also held in private collections. Cassatt was born in Allegheny City, which is now part of Pittsburgh, Pennsylvania, on May 22, 1844. She was born into a well-to-do family of French Huguenot heritage. Her father was Robert Simpson Cassat (who later changed his surname to Cassatt), a successful stockbroker and land speculator, and her mother was Katherine Kelso Johnston Cassatt, whose family was in the banking business. The family's ancestral name was Cossart. Cassatt was one of seven children. Two of her siblings died in infancy. Eventually, the Cassatt family moved eastward, first to Lancaster, Pennsylvania, then to the Philadelphia area, where Cassatt entered school at the age of six.

At an early age, Cassatt was introduced to the European experience. It was considered a vital part of her education. She spent five years with her family visiting many of the European capitals, including London, Paris, and Berlin. She took her first lessons in drawing and music while abroad and also learned German and French. Cassatt was among the throngs who toured the World's Fair of 1855 in Paris. It is likely that she would have viewed the works of the French artists Ingres, Delacroix, Corot, Degas, Pissarro, and Courbet, all of whom were exhibited at the fair. Degas and Pissarro would both be future

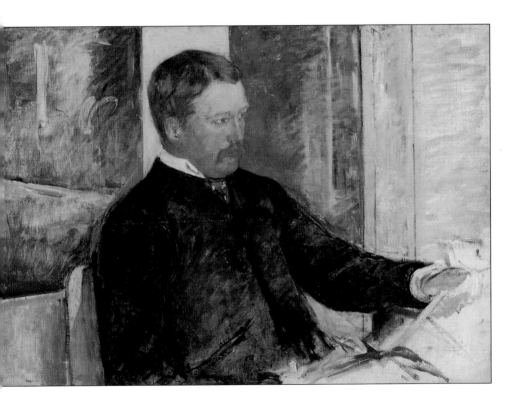

Portrait of Alexander J. Cassatt, 1880,
Detroit Institute of Arts

colleagues and mentors.

At the age of 15, over her family's objections, Cassatt began to study painting at the Pennsylvania Academy of the Fine Arts in Philadelphia and in so doing was launched on the career path she desired. Unlike many of the students at that time, Cassatt's goal was to be a professional artist. She was not studying merely to hone a skill or talent, but to make a name for herself in the competitive and uncompromising milieu of the world's most talented and respected artists.

Cassatt continued her studies during the years of the U.S. Civil War, although her family, and in particular her father, was not enthusiastic about her chosen profession. Only about 20 percent of the students at the academy were female. While this may have played a role in her family's lackluster support, part of their concern may also have been Cassatt's exposure to feminist ideas and the bohemian behavior of some of the male students at the academy.

Cassatt became disillusioned with the academy, believing that the instruction was slow and that the male students and teachers were patronizing to the female students, who had a rather second-class status. Female students could not use live models, for example. So, she took the development of her career into her own hands and persuaded her parents to let her study in Paris where she could learn by copying the old masters.

Chaperoned by her mother and family friends, Cassatt moved to Paris in 1865. Because women could not yet attend the Ecole des Beaux-Arts, she applied to study privately with masters from the school. Cassatt began taking private lessons from the leading academic painter Jean-Léon Gérômem, a highly regarded teacher known for his hyper-realistic technique and his depiction of exotic subjects.

Cassatt also studied the old masters on her own by daily copying in the Louvre. Like the other "copyists," she obtained the required permit that was used to control their numbers in the museum. The copyists were usually low-paid women who painted copies of the Louvre's masterpieces for sale to the public. The Louvre was also a social meeting place for French men and American female students who were not allowed to attend cafes where the avant-garde socialized.

During this time, Cassatt also spent time in Courance and Écouen, two suburbs of Paris, and continued her studies with Édouard Frère, a noted publisher and an expert on printing, and the artist Paul Soyer. Toward the end of 1866, she joined a painting class taught by Charles Chaplin, a noted genre artist. In 1868, Cassatt also studied with artist Thomas Couture, whose subjects were mostly romantic and urban. But on frequent trips to the

countryside, Cassatt and her fellow students portrayed the bucolic life of peasants as they went about their daily activities.

In 1868, Cassatt's painting, *The Mandolin Player*, was accepted at the Paris Salon, which at that time was the greatest annual or biannual art event in the Western world. It was the first time her work was represented there, and it would be far from the last time. *The Mandolin Player* is in the Romantic style of Corot and Couture, and is one of only two paintings from the first decade of Cassatt's career that can be documented today.

After three-and-a-half years in Paris, Cassatt was forced to return to the United States in the summer of 1870 after the outbreak of the Franco-Prussian War. Her family, whom she rejoined, was then living in Altoona, Pennsylvania. Her father's opinion of her chosen occupation had not mellowed over the years that she was in France. He held fast to his opposition, agreeing to pay for her basic needs, but refusing to provide her art supplies.

Although Cassatt was able to place two of her paintings in a New York gallery, they did not sell and her desire to make a living as a professional artist still eluded her. She also sorely missed the Louvre and the other museums of Paris because she was frustrated by the lack of seriously good paintings near her home in Pennsylvania from which to study and copy. So dismayed was she that Cassatt even considered giving up art. Quite the feminist, Cassatt was determined to make an independent living—even if it wouldn't be through art.

In search of employment, Cassatt traveled to Chicago. Unfortunately, that move cost her dearly: she lost some of her early paintings in the Great Chicago Fire of October 1871. Shortly thereafter, however, the Archbishop of Pittsburgh commissioned her to produce two copies of paintings by Correggio in Parma, Italy. In the autumn of 1871, Cassatt set off excitedly for Parma accompanied by Emily Sartain, a fellow artist from a well-regarded artistic family of Philadelphia, and with financial support from the archbishop to pay for her travel expenses.

The commission by the Archbishop of Pittsburgh was a turning point in Cassatt's career. For the majority of 1872, she was in Parma, studying the paintings of Correggio and Parmigianino, and consulting with Carlo Raimondi, head of the department of engraving at the Parma Academy. While in Parma, she painted *Two Women Throwing Flowers During Carnival*, which was accepted in the Paris Salon of 1872 and—more importantly—was sold! Not only was Cassatt receiving high praise and much favorable attention from the art community in Parma, she was also gaining recognition in Paris, the center of the art world.

In 1873, after completing her commission for the archbishop, Cassatt traveled to Spain, Belgium, and Holland to study and copy the works of Velázquez, Rubens, and Hals. In Madrid and Seville, she painted several Spanish subjects, including *Spanish Dancer Wearing a Lace Mantilla*.

A year later Cassatt returned to Paris to live and work. She began to show regularly in the Paris Salons, but also began to express criticism of the politics of the Salon and the conventional taste that prevailed in the jury selection process. Cassatt observed that the jury was often biased against the works of female artists unless the artist was well connected to a member of the jury. Cassatt refused to play that political game. It was the last straw when one of the two works she submitted to the Salon in 1875 was refused by the jury, but was accepted the following year with only the minor change of a darkened background. Her outspokenness and cynicism regarding the Salon caused Cassatt to quarrel with her old friend Emily Sartain, and they ultimately parted ways.

In 1877 Cassatt was joined in Paris by her parents and her sister Lydia, who never married. Lydia suffered from recurring illness and died in 1882. Her death would so devastate Cassatt that she would be temporarily unable to work.

In the same year, both of Cassatt's entries to the Paris Salon were rejected, and for the first time in seven years she had no works exhibited in the Salon. Growing increasingly dismayed with her professional prospects, she vowed to move away from genre paintings and to attempt to attract portrait commissions from American socialites abroad. This new endeavor was going slowly, so when Cassatt was invited by Edgar Degas to join the group of independent artists later known as the Impressionists, she eagerly accepted the overture. Cassatt was the only American officially associated with the group and only the second female. Artist Berthe Morisot, who became Cassatt's friend and colleague, was the first women to be invited to join.

The Impressionists—also known as the Independents or Intransigents—were viewed as quite radical by many art critics. The group's members varied considerably in their subject matter and technique, but tended to prefer open-air painting and vibrant color applied in separate strokes with little pre-mixing, which forced the eye to merge the results in an "impressionistic" manner. The group began its own series of independent exhibitions in 1874 that were viewed with much disrepute. Cassatt exhibited in four of the Impressionist exhibitions: 1879, 1880, 1881, and 1886.

Under the influence of the Impressionists, in particular Degas, Cassatt found the new direction she had been seeking in order to

revitalize her career. She revised her technique, composition, and use of color and light under the watchful and critical eye of Degas, her chief mentor. Not only did Cassatt share Degas' strong interest in figure compositions, she also found inspiration in pastels—a new medium for her in which he was well skilled. It is said that when Cassatt first saw Degas' pastels in a Parisian art dealer's window in 1875, they had a profound impact upon her, and she declared that she then saw art as she wanted to see it.

In fact, Cassatt became so proficient in the use of pastels that she created many of her works in this medium, including *Louisine Havemeyer and Her Daughter, Electra* (1895), *Margot in Orange Dress* (1902), and *Margot in Blue* (1902). Degas also introduced her to copper engraving, a technique that he had mastered, in order to strengthen her control of line and improve her overall draftsmanship. The tables were turned when Cassatt became Degas' subject in a series of etchings that recorded their visits together to the Louvre. Cassatt and Degas enjoyed a unique and inspiring relationship. Both rejected conservative artistic directions, and they encouraged and facilitated the work of the other.

Applying her new Impressionist techniques, Cassatt produced some outstanding paintings for the Impressionist exhibition planned in 1878, but which was postponed to 1879 because of the Paris World's Fair in 1878. Three of her most accomplished works from 1878 were the self-portrait *Portrait of the Artist*, *Little Girl in a Blue Armchair*, and *Reading "Le Figaro,"* which is a portrait of her mother.

The Impressionist Exhibition of 1879 was more successful than any of the previous exhibitions, actually making a profit for each participating member through the public relations efforts and underwriting of Gustave Caillebotte. The success came despite the absence of Renoir, Sisley, Manet and Cezanne, whose attentions had once again returned to the Salon. Regardless of the financial success of the exhibit, the criticism continued to be as harsh as ever. The *Revue des Deux Mondes* wrote: "M. Degas and Mlle. Cassatt are, nevertheless, the only artists who distinguish themselves and who offer some attraction and some excuse in the pretentious show of window dressing and infantile daubing."

Cassatt showed 11 works, including *La Loge*. She used her share of the profits to purchase a work by Degas and one by Monet. She participated in the Impressionist exhibitions of 1880 and 1881, and remained an active member of the Impressionist circle until 1886. In 1886, Cassatt supplied two paintings for the first Impressionist exhibition in the United States, organized by art dealer Paul Durand-Ruel, the best-known art dealer

and most important commercial advocate of Impressionism in the world during the last three decades of the 19th century. He almost single-handedly established the market for Impressionism in the United States as well as in Europe.

Cassatt's contribution to history lies not only in the art she produced, but also in the role she played in bringing the work of the major Impressionists, such as Degas, Manet, and Corot, as well as other artists, such as El Greco and Rembrandt, to the United States. Before they quarreled over Cassatt's outspoken criticisms of the Paris Salon, Emily Sartain introduced Cassatt to Louisine Elder, an American art student who was also studying in Paris. In 1883, at the age of 17, Louisine Elder married Harry Havemeyer, a founder and later president of the American Sugar Refining Company (later Domino Sugar). Relying on Cassatt's advice, the couple began collecting the Impressionists on a grand scale, beginning with a purchase of a pastel by Degas believed to be the first Degas to be bought by a North American collector. Much of their vast collection is now in the Metropolitan Museum of Art in New York City.

During her Impressionist period, she made several portraits of family members of which *Portrait of Alexander J. Cassatt and His Son, Robert Kelso Casdatt* (1884) is one of her best regarded. Cassatt's style then evolved, and she moved away from Impressionism to a simpler, more straightforward approach. She also began to exhibit her works in New York galleries. After 1886, Cassatt no longer identified herself with any art movement and experimented with a variety of techniques.

Cassatt's popular reputation is based on her paintings and prints on the theme of the mother and child. The earliest-dated work on this subject is the drypoint *Gardner Held by His Mother*, which is inscribed "Jan/88" and is in the New York Public Library. *Maternité* (1890) is another example in this theme. Some of her earliest works of this nature depict her relatives, friends, or clients, but her later works generally relied upon professional models in compositions that recall Italian Renaissance depictions of the Madonna and child. After 1900, Cassatt concentrated almost exclusively on mother-and-child subjects.

In 1891, she exhibited a series of highly original colored drypoint and aquatint prints, including *Woman Bathing* and *The Coiffure*, inspired by the Japanese masters who had been shown in Paris the year before. The style of painting known as Japonism is characterized by a lack of perspective and shadow, flat areas of strong color, compositional freedom in placing the subject off-center, and having a low diagonal axis to the background. Cassatt's interpretation of Japonism employed primarily light, delicate,

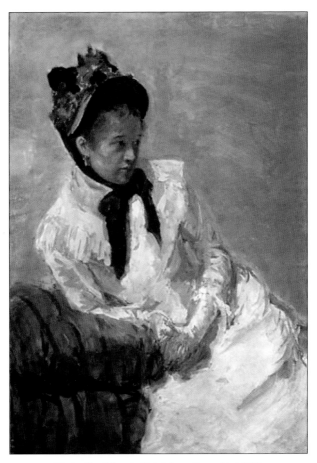

Portrait of the Artist, Mary Cassatt, 1878,
The Metropolitan Museum of Art, New York City

pastel colors. Cassatt was not the only artist to have been influenced by Japonism. Pierre Bonnard, Henri de Toulouse-Lautrec, Edgar Degas, August Renoir, James McNeill Whistler, Claude Monet, Vincent van Gogh, Camille Pissarro, Paul Gauguin, Aubrey Beardsley, Alphonse Mucha, and Gustav Klimt all produced works inspired by the simplicity and clarity of this type of design.

The 1890s were Cassatt's busiest and most creative period of her professional career. From this period are her works *Summertime* (1894), *The Boating Party* (1893–94), and *The Pink Sash* (1898). With maturity, Cassatt became more diplomatic and less blunt in her opinions. She was a role model for young American artists who sought her advice. Among them was Lucy A. Bacon, whom Cassatt introduced to Camille Pissarro. Although the Impressionist group had disbanded, Cassatt was still in contact with Renoir, Monet, and Pissarro, among others.

Cassatt served as an advisor to several major art collectors, including her brothers and the Havemayers, encouraging them to eventually donate their purchases to American art museums. Although instrumental in advising American collectors, appreciation of the artworks she created herself materialized quite slowly in the United States.

Even among her family members, she received little recognition and was totally overshadowed by her famous brother Alexander, who was president of the Pennsylvania Railroad from 1899 until his death in 1906. Although Cassatt was shaken by his death because they had been close, she continued to be very productive, unlike after her sister Lydia's death.

An increasing sentimentality is apparent in her work during the 1900s. Her work of this period was popular with the public and the critics, but she was no longer breaking new ground, and her Impressionist colleagues who once provided stimulation and criticism were dying off. She was hostile to such new developments in art as Post-Impressionism, Fauvism, and Cubism.

Cassatt's other brother, Gardner, died suddenly after a trip to Egypt in 1910. Cassatt had joined her brother and his family on a tour of this ancient land whose art so impressed her with its beauty that it triggered a crisis of creativity. Certainly, at 66, she was exhausted after such a distant and strenuous trip, but was likewise emotionally drained by her brother's death as well as by her overpowering reaction to Egyptian art, declaring herself "crushed by the strength of this Art."

One year later, she was diagnosed with diabetes, rheumatism, neuralgia, and cataracts, but she maintained a steady flow of work. In 1914, almost blind, she had no choice—she

was forced to stop painting. Undeterred by her physical ailments, Cassatt embraced the cause of women's suffrage, just as her old friend Louisine Havemayer did. In 1915, Cassatt showed 18 works in an exhibition to raise funds to support the suffrage movement.

Cassatt spent most of her life in France, and she gained most of her fame and success in Europe. In recognition of her contributions to the arts, France awarded her the Legion d'honneur in 1904. Not until after her death on June 14, 1926, at Chateau de Beaufresne, near Paris, did she become a truly celebrated American artist. She was buried in the family vault at Mesnil-Theribus, France.

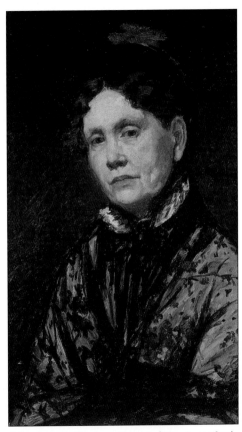

Mrs. Robert Simpson Cassatt (Mary's mother), 1873, Private Collection

Plate 1

CHILD DRINKING MILK
1868, Private Collection
Dimensions unknown

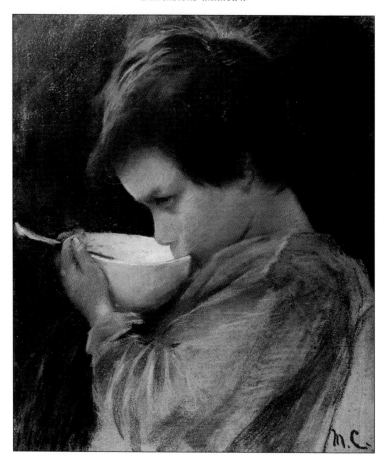

THE BACCHANTE

Plate 2

1872, Pennsylvania Academy of the Fine Arts, Philadelphia
61 x 50.6 cm

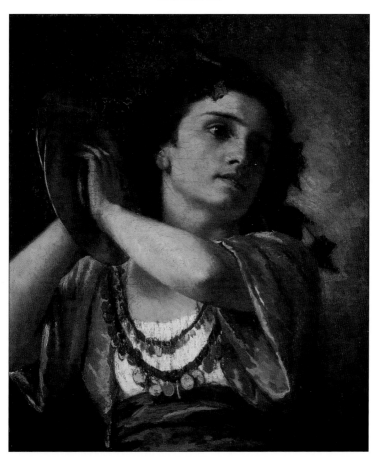

Plate 3

THE MANDOLIN PLAYER
1872, Private Collection
91.44 x 73.66 cm

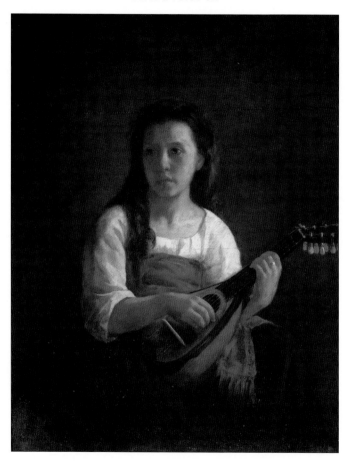

TWO WOMEN THROWING FLOWERS DURING CARNIVAL *Plate 4*

1872, Private Collection
63.5 x 54.61 cm

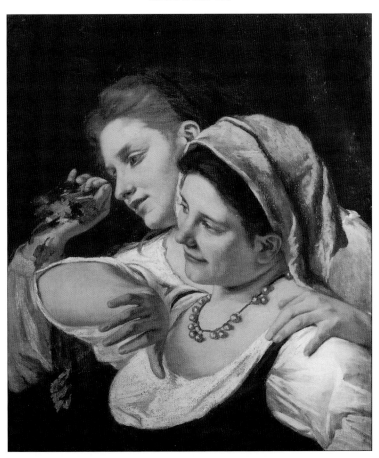

Plate 5

ON THE BALCONY
1873, Philadelphia Museum of Art
101 x 54.6 cm

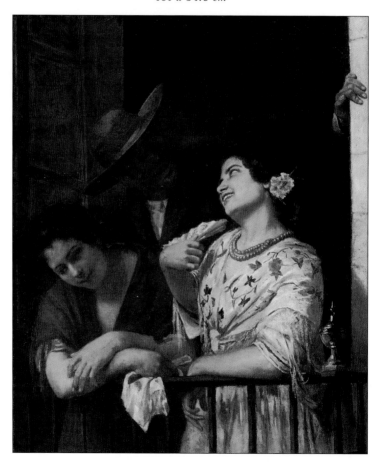

Plate 6

SPANISH DANCER WEARING A LACE MANTILLA

1873, Smithsonian American Art Museum, Washington, DC
65.2 x 50.1 cm

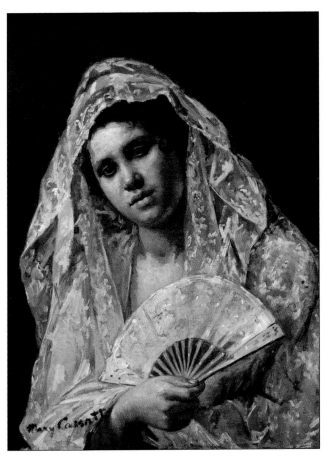

Plate 7

OFFERING THE PANAL TO THE BULLFIGHTER

1873, Sterling and Francine Clark Art Institute, Williamstown, Massachusetts
100.6 x 85.1 cm

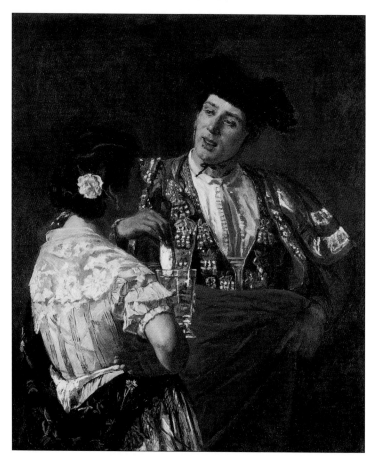

MARY ELLISON EMBROIDERING

Plate 8

1877, Philadelphia Museum of Art
74.3 x 59.7 cm

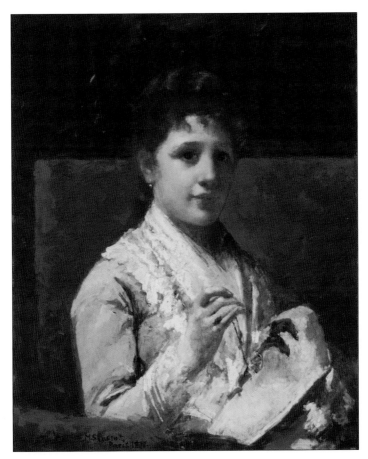

Plate 9

LITTLE GIRL IN A BLUE ARMCHAIR
1878, National Gallery of Art, Washington, DC
89.5 x 129.5 cm

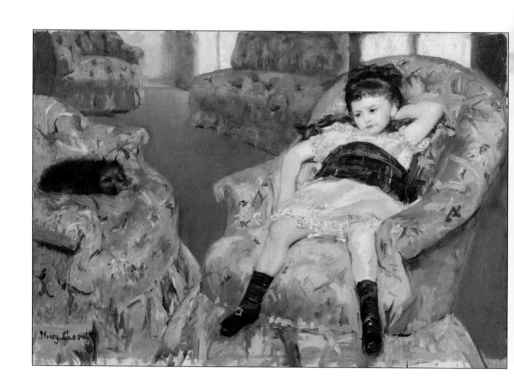

Plate 10

IN THE LOGE
1878, Museum of Fine Arts Boston
81.28 x 66.4 cm

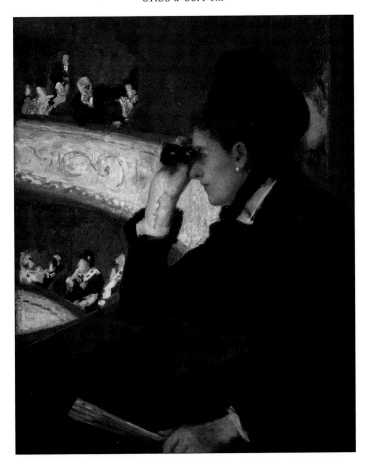

Plate 11

CHILDREN IN A GARDEN (THE NURSE)

1878, The Museum of Fine Arts, Houston
65.4 x 80.9 cm

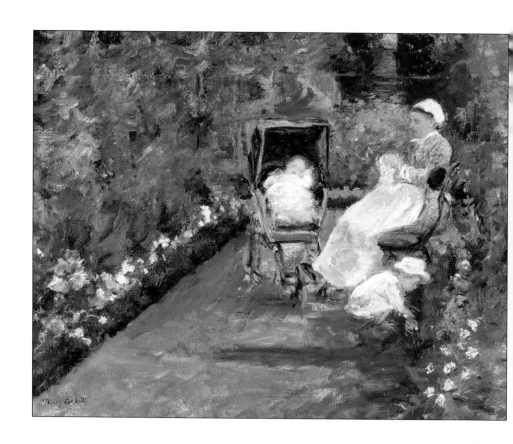

Plate 12

READING "LE FIGARO"
1878, Private Collection
104 x 84 cm

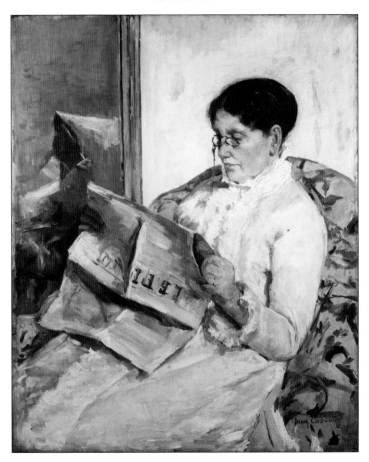

Plate 13

ON A BALCONY
1878–79, The Art Institute of Chicago
89.9 x 65.2 cm

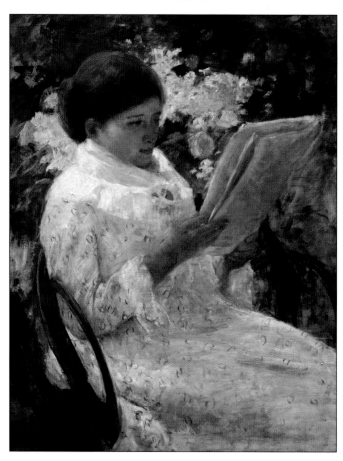

WOMAN WITH A PEARL NECKLACE IN A LOGE

Plate 14

1879, Philadelphia Museum of Art
81.3 x 59.7 cm

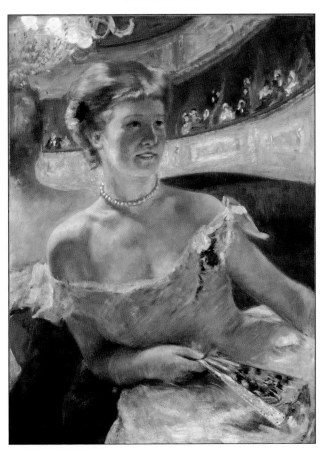

Plate 15

WOMAN WITH A FAN

c. 1878–79, National Gallery of Art, Washington, DC
85.5 x 65.1 cm

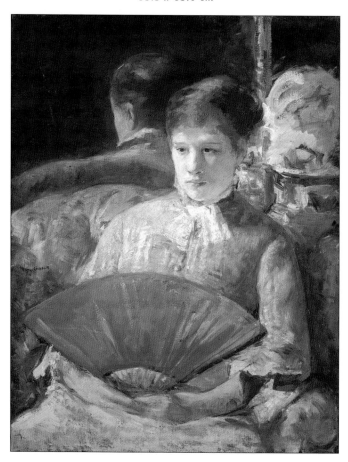

Plate 16

THE LOGE

c. 1878-1880, National Gallery of Art, Washington, DC
79.8 x 63.8 cm

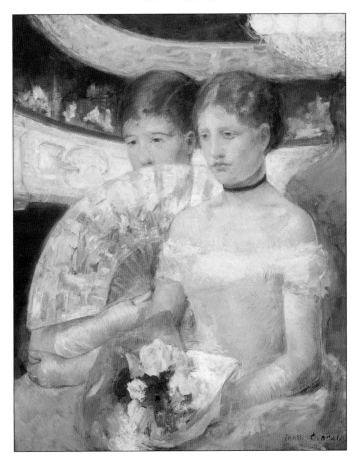

Plate 17

THE READER
1878, Private Collection
Dimensions unknown

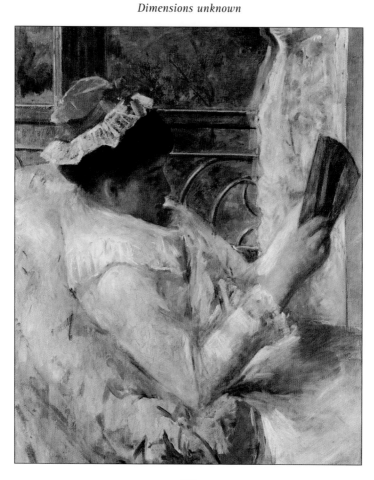

LYDIA CROCHETING IN THE GARDEN AT MARLY

Plate 18

1880, The Metropolitan Museum of Art, New York City
65.6 x 92.6 cm

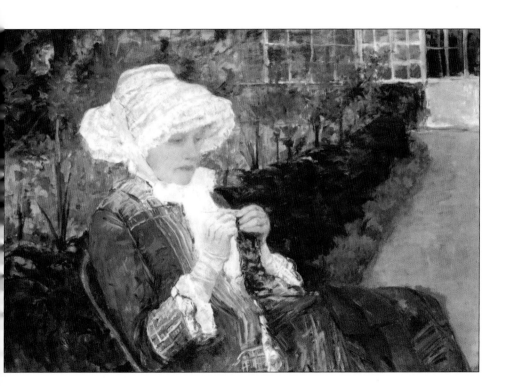

Plate 19

MARY CASSATT SELF-PORTRAIT

c. 1880, The National Portrait Gallery, Smithsonian Institution, Washington, DC
32.7 x 24.6 cm

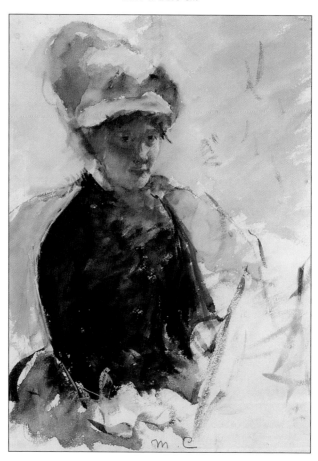

Plate 20

THE TEA
c. 1880, Museum of Fine Arts Boston
64.7 x 92 cm

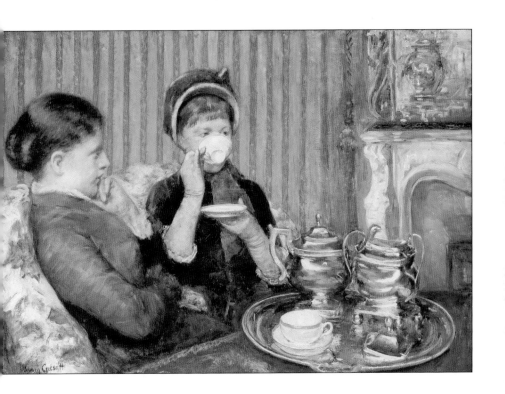

Plate 21

MOTHER ABOUT TO WASH HER SLEEPY CHILD

1880, Los Angeles County Museum of Art
100.33 x 65.72 cm

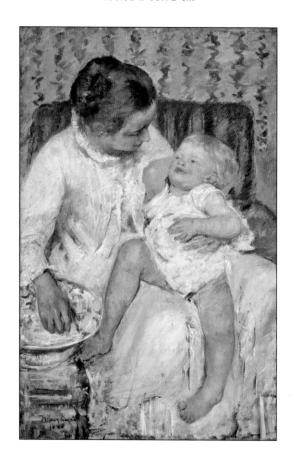

YOUNG GIRL IN THE GARDEN

1880–82, Musée d'Orsay, Paris
92.5 x 65 cm

Plate 22

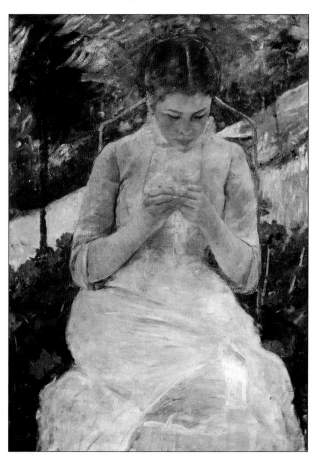

Plate 23

A WOMAN AND A GIRL DRIVING
1881, Philadelphia Museum of Art
89.7 x 130.5 cm

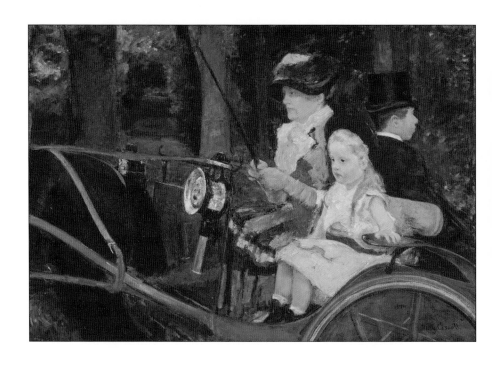

LADY AT THE TEA TABLE

Plate 24

1883–85, The Metropolitan Museum of Art, New York City
73.7 x 61 cm

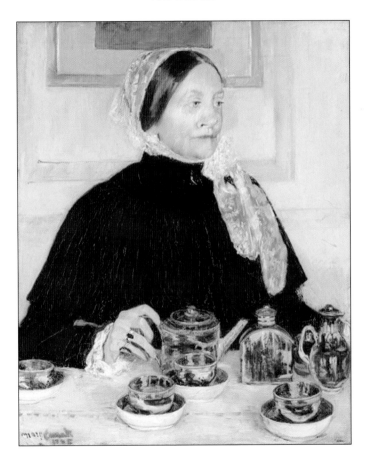

Plate 25

PORTRAIT OF ALEXANDER J. CASSATT AND
HIS SON, ROBERT KELSO CASSATT
1884, Philadelphia Museum of Art
100.3 x 81.3 cm

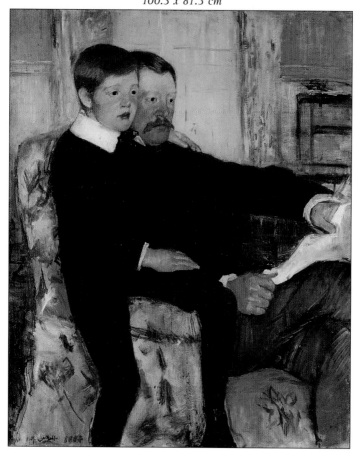

CHILDREN PLAYING ON THE BEACH

Plate 26

1884, National Gallery of Art, Washington, DC
97.4 x 74.2 cm

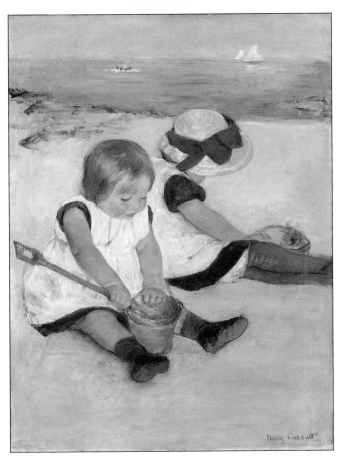

Plate 27

GIRL ARRANGING HER HAIR
1886, National Gallery of Art, Washington, DC
75.1 x 62.5 cm

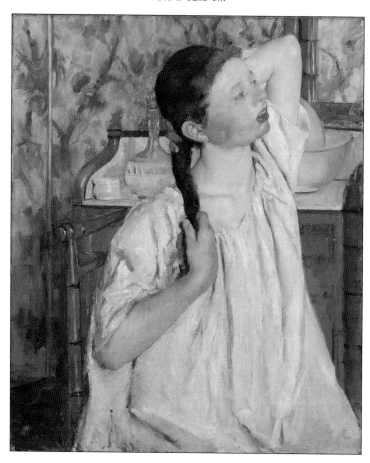

Plate 28

CHILD IN A STRAW HAT

c. 1886, National Gallery of Art, Washington, DC
65.3 x 49.2 cm

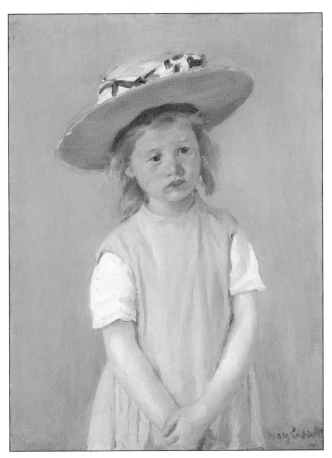

Plate 29

LITTLE ANN SUCKING HER FINGER
EMBRACED BY HER MOTHER
1887, Musée d'Orsay, Paris
55 x 46 cm

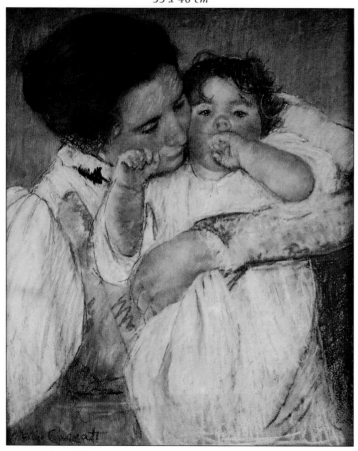

Plate 30

PORTRAIT OF AN ELDERLY LADY
c. 1887, National Gallery of Art, Washington, DC
72.9 x 60.3 cm

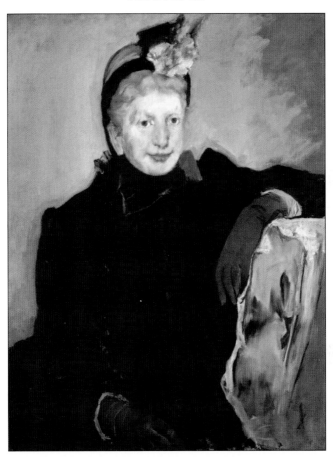

Plate 31

MRS. ROBERT S. CASSATT, THE ARTIST'S MOTHER

c. 1889, de Young Museum, San Francisco
96.5 x 68.5 cm

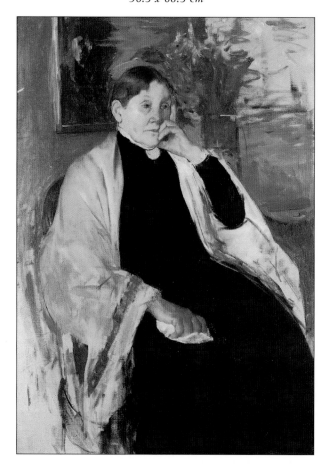

Plate 32

WOMAN AND CHILD IN FRONT OF A SMALL TABLE
WITH PITCHER AND BASIN (MOTHER AND CHILD)

c. 1889, Musée d'Orsay, France

65 x 50 cm

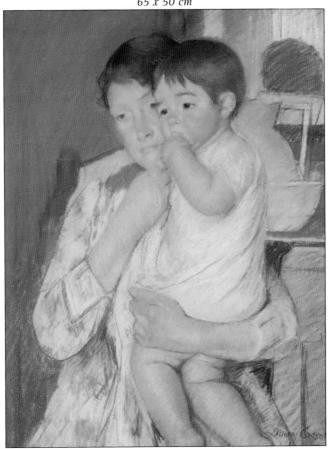

Plate 33

MOTHER AND CHILD

1890, Wichita Art Museum, Wichita, Kansas
90.2 x 64.5 cm

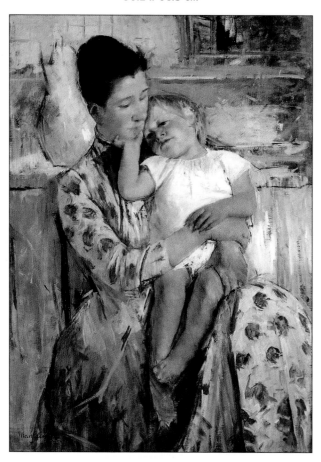

THE CHILD'S CARESS
1890, Honolulu Museum of Art
Dimensions unknown

Plate 34

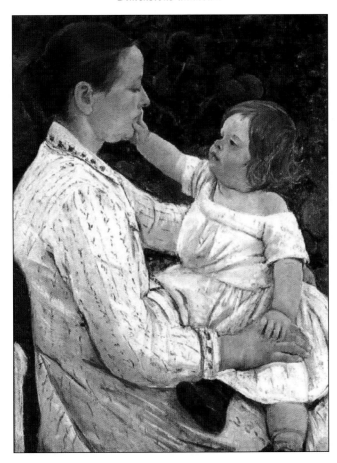

Plate 35

WOMAN SITTING WITH A CHILD IN HER ARMS

c. 1890, Museo de Bellas Artes de Bilbao, Spain
81 x 65.5 cm

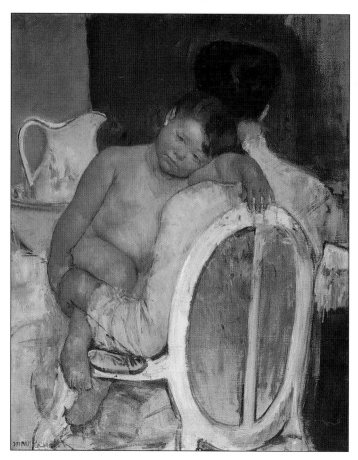

Plate 36

MATERNITÉ
1890, Private Collection
68.6 x 44.4 cm

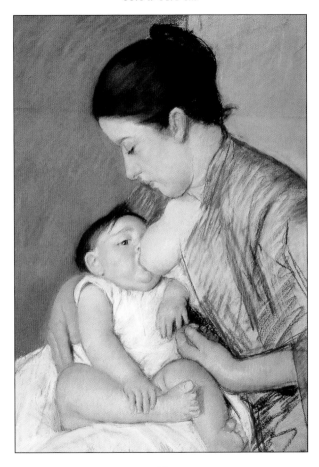

Plate 37

THE BATH
1890–91, National Gallery of Art, Washington, DC
31.9 x 24.9 cm

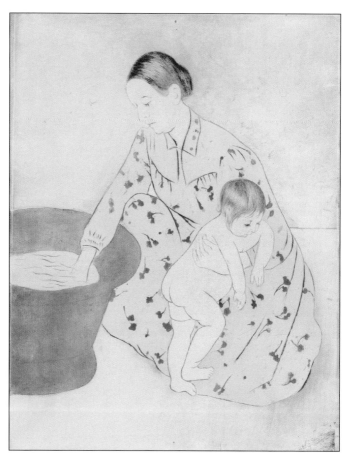

IN THE OMNIBUS

Plate 38

1890–91, National Gallery of Art, Washington, DC
36.5 x 26.6 cm

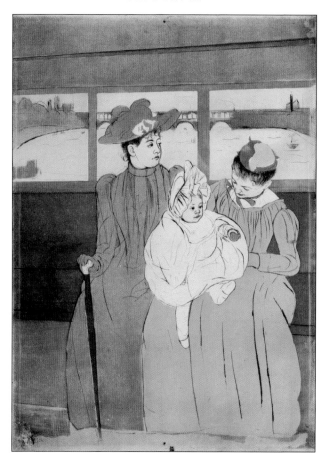

Plate 39

MATERNAL CARESS
1891, The Metropolitan Museum of Art, New York City
36.5 x 27 cm

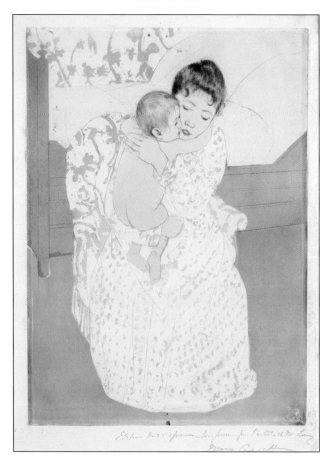

WOMAN BATHING

Plate 40

1891, The Metropolitan Museum of Art, New York City
36.4 x 26.8 cm

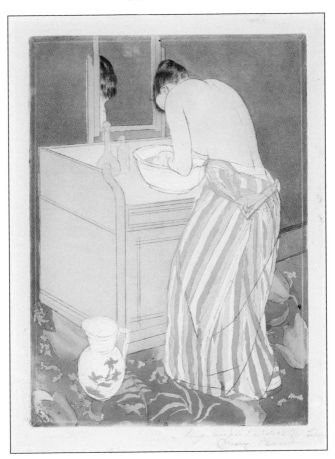

Plate 41

THE COIFFURE

1890–91, National Gallery of Art, Washington, DC
36.5 x 26.7 cm

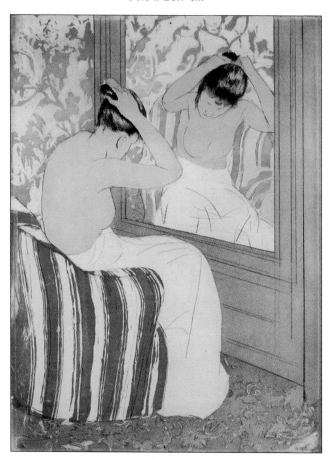

WOMAN WITH A RED ZINNIA

Plate 42

1891, National Gallery of Art, Washington, DC
73.6 x 60.3 cm

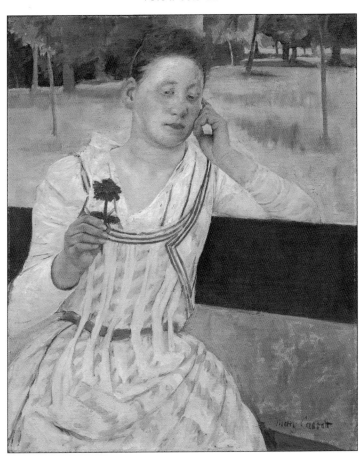

Plate 43

THE LETTER
1891, National Gallery of Art, Washington, DC
36.6 x 22.6 cm

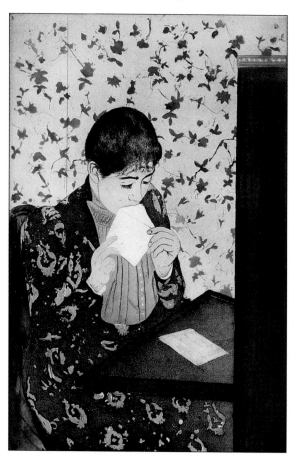

YOUNG WOMEN PICKING FRUIT

Plate 44

1892, Carnegie Museum of Art, Pittsburgh, Pennsylvania
131.44 x 90.17 cm

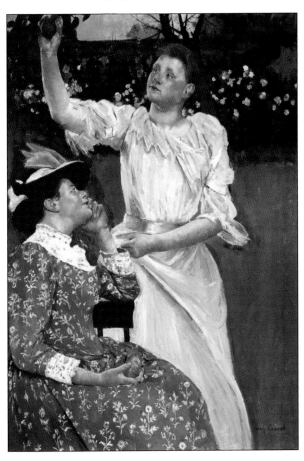

Plate 45

THE CHILD'S BATH
1893, The Art Institute of Chicago
100.3 x 66.1 cm

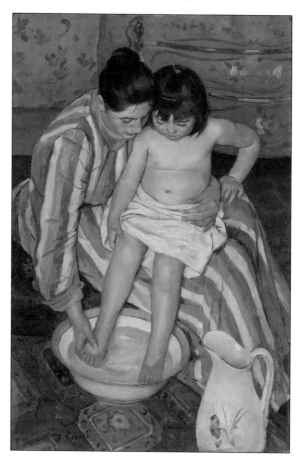

Plate 46

CHILD PICKING A FRUIT
1893, Virginia Museum of Fine Arts, Richmond
100.33 x 65.41 cm

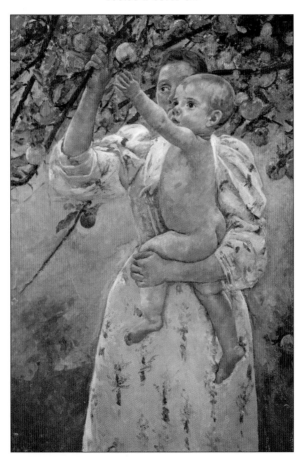

Plate 47

THE BOATING PARTY

1893–94, National Gallery of Art, Washington, DC
90 x 117.3 cm

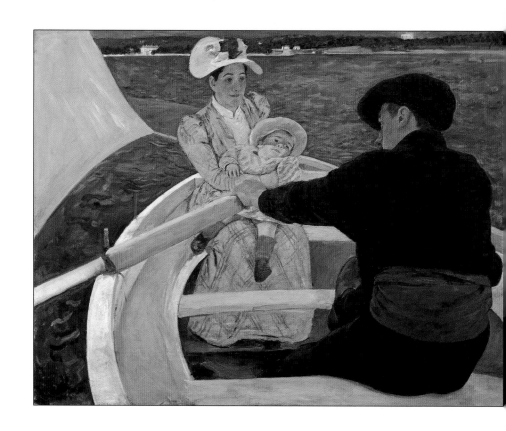

GATHERING FRUIT

Plate 48

1893, National Gallery of Art, Washington, DC
42 x 29.8 cm

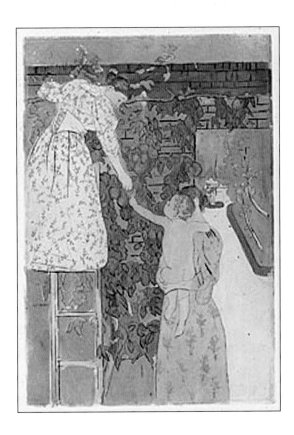

Plate 49

THE FAMILY
1893, Private Collection
81.9 x 66.4 cm

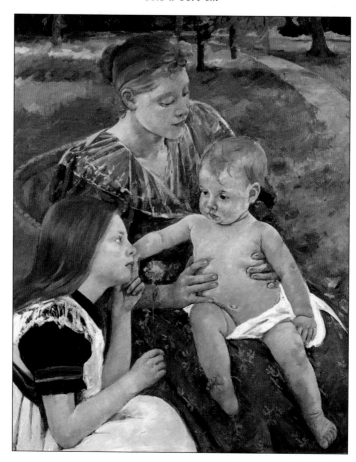

Plate 50

SUMMERTIME
1894, Hammer Museum, Los Angeles
81.3 x 100.6 cm

Plate 51

LOUISINE HAVEMEYER AND
HER DAUGHTER, ELECTRA

1895, Shelburne Museum, Shelburne, Vermont
61 × 77.5 cm

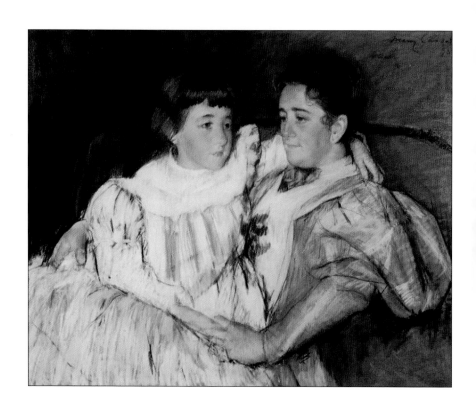

Plate 52

NURSE READING TO A LITTLE GIRL
1895, The Metropolitan Museum of Art, New York City
60.325 x 73.66 cm

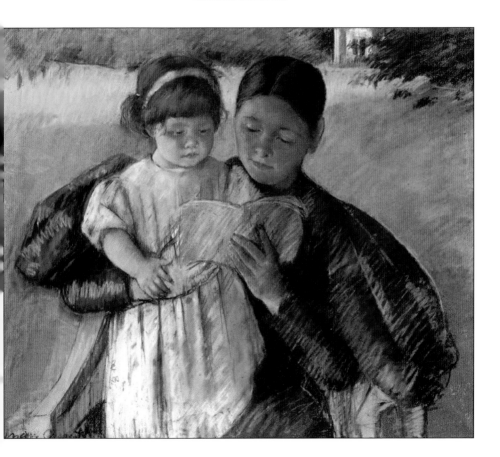

Plate 53

MATERNAL CARESS
c. 1896, Philadelphia Museum of Art
38.1 x 54 cm

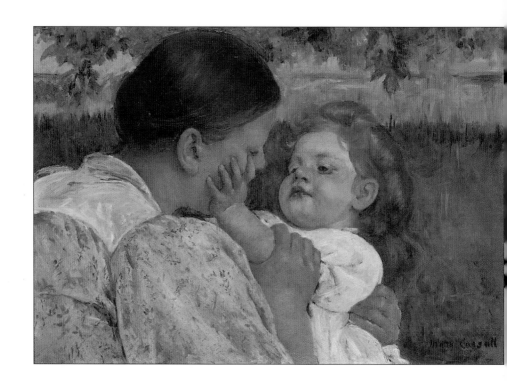

Plate 54

ELLEN MARY IN A WHITE COAT

c. 1896, Museum of Fine Arts Boston
81.28 x 60.32 cm

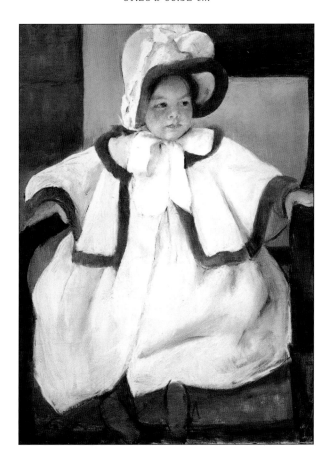

Plate 55

WOMEN ADMIRING A CHILD
1897, Detroit Institute of Arts
81.3 x 66 cm

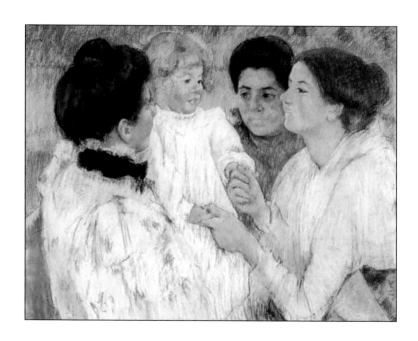

Plate 56

UNDER THE HORSE CHESTNUT TREE

1896–97, The Metropolitan Museum of Art, New York City
52.1 x 38.6 cm

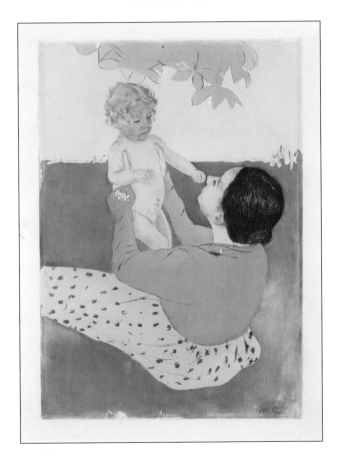

Plate 57

BREAKFAST IN BED

1897, The Huntington, Pasadena, California
65 x 73.7 cm

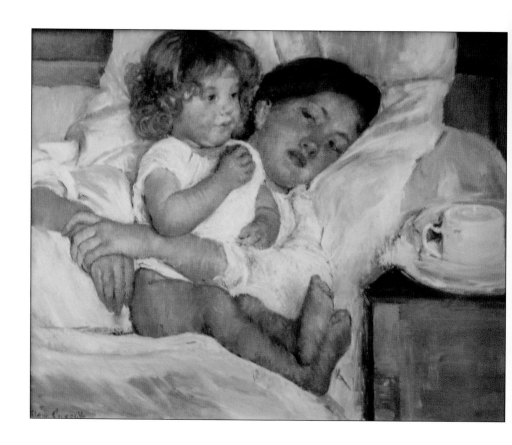

Plate 58

MATERNITY

1897, Musée d'Orsay, Paris
53 x 45 cm

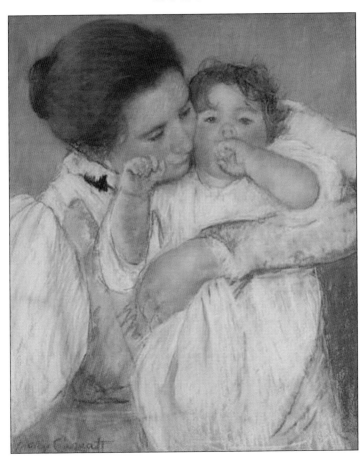

Plate 59

A KISS FOR BABY ANNE
1897, Private Collection
54.6 x 46.36 cm

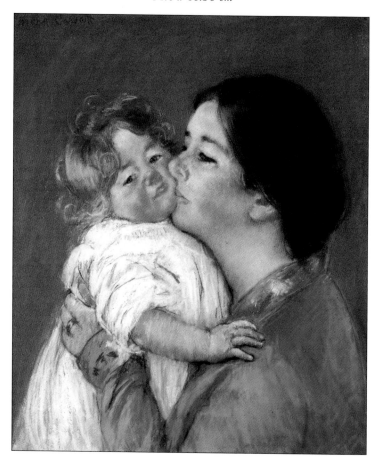

Plate 60

MADAME GAILLARD AND
HER DAUGHTER MARIE-THÉRÈSE

1897, Reynolda House Museum of American Art, Winston-Salem, North Carolina
57.8 x 71.1 cm

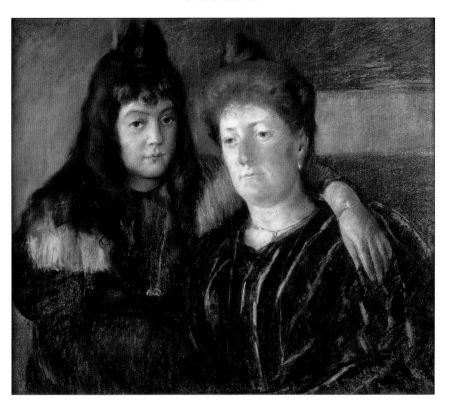

Plate 61

FAMILY GROUP READING
1898, Philadelphia Museum of Art
56.5 x 112.4 cm

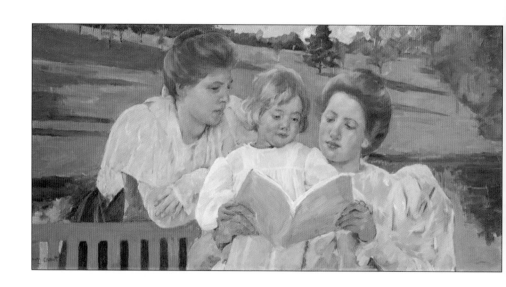

MOTHER AND CHILD (BABY GETTING UP FROM HIS NAP) *Plate 62*

c. 1899, The Metropolitan Museum of Art, New York City
92.7 x 73.7 cm

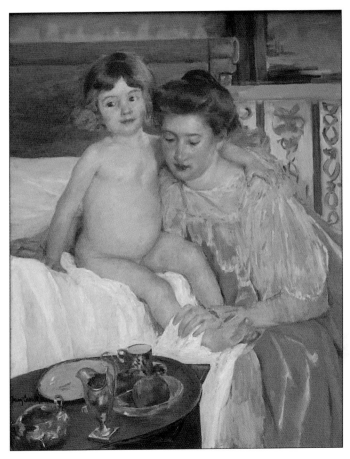

Plate 63

PORTRAIT OF A YOUNG GIRL

1899, The Metropolitan Museum of Art, New York City
73.7 x 61.3 cm

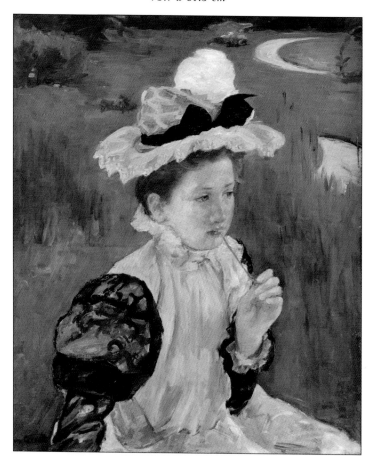

YOUNG GIRLS

c. 1900, Indianapolis Museum of Art
63.5 x 52.7 cm

Plate 64

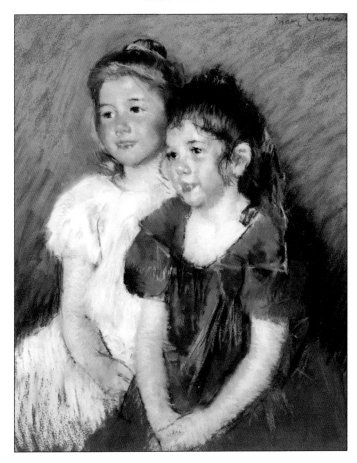

Plate 65

YOUNG MOTHER SEWING

1900, The Metropolitan Museum of Art, New York City
92.4 x 73.7 cm

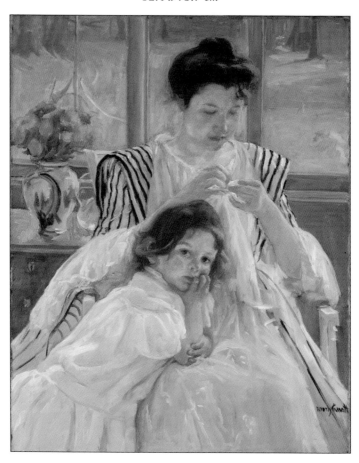

JULES BEING DRIED BY HIS MOTHER

1900, Private Collection
92.7 x 73 cm

Plate 66

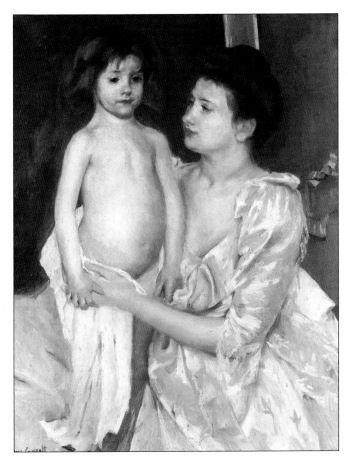

Plate 67

MOTHER BERTHE HOLDING HER BABY

1900, Private Collection
57.15 x 45.1 cm

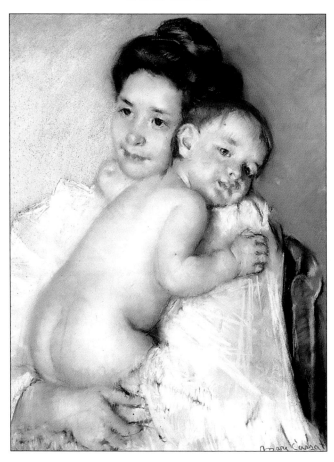

Plate 68

MOTHER COMBING HER CHILD'S HAIR

c. 1901, Brooklyn Museum, New York City
64.1 x 80.3 cm

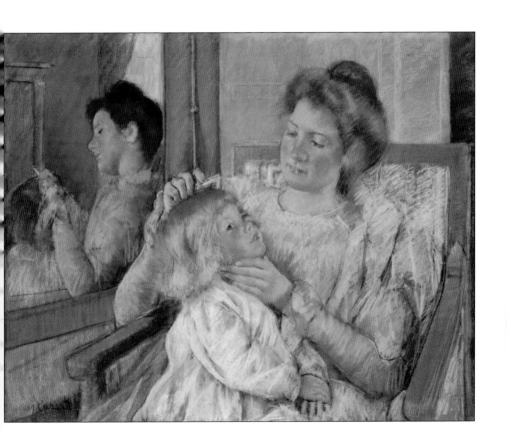

Plate 69

AFTER THE BATH
1901, Cleveland Museum of Art, Ohio
66 x 100 cm

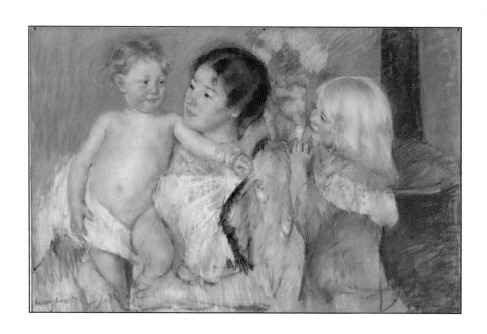

Plate 70

WOMAN IN A RED BODICE AND HER CHILD

c. 1901, Brooklyn Museum, New York City
68.6 x 51.4 cm

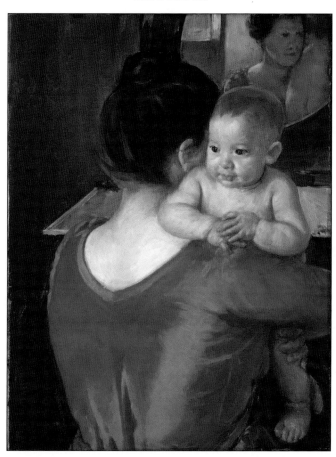

Plate 71

THE CARESS

1902, Smithsonian American Art Museum, Washington, DC
83.4 x 69.4 cm

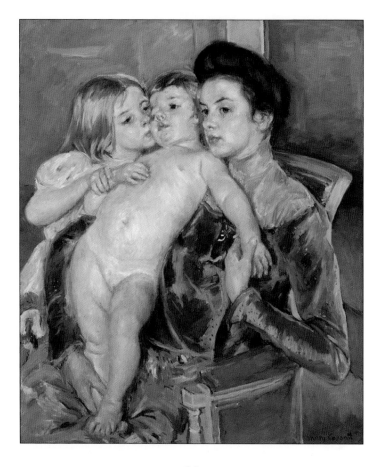

MARGOT IN ORANGE DRESS

Plate 72

1902, The Metropolitan Museum of Art, New York City
72.4 x 59.4 cm

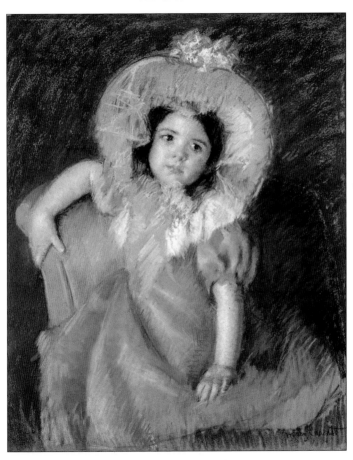

Plate 73

MARGOT IN BLUE
1902, The Walters Art Museum, Baltimore
61.3 x 50.2 cm

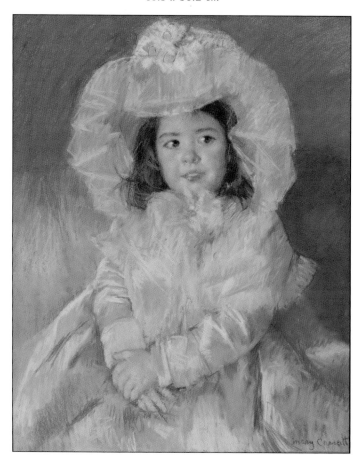

Plate 74

REINE LEFEBVRE HOLDING A NUDE BABY
(MOTHER AND CHILD)
1902–03, Worcester Art Museum, Worcester, Massachusetts
68.1 x 57.3 cm

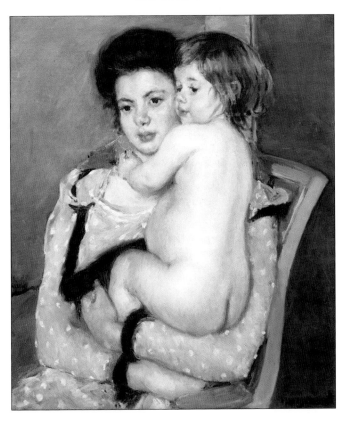

Plate 75

PORTRAIT OF DOROTHY

c. 1904, The Nelson-Atkins Museum of Art, Kansas City, Missouri
58.42 x 43.18 cm

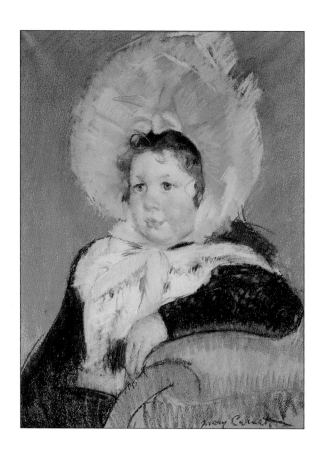

Plate 76

MOTHER AND CHILD
c. 1905, National Gallery of Art, Washington, DC
92.1 x 73.7 cm

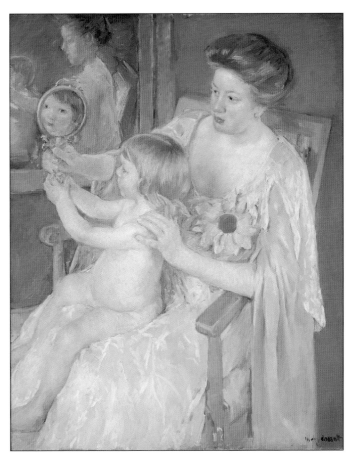

Plate 77

MOTHER AND CHILD WITH A ROSE SCARF
c. 1908, The Metropolitan Museum of Art, New York City
116.8 x 89.5 cm

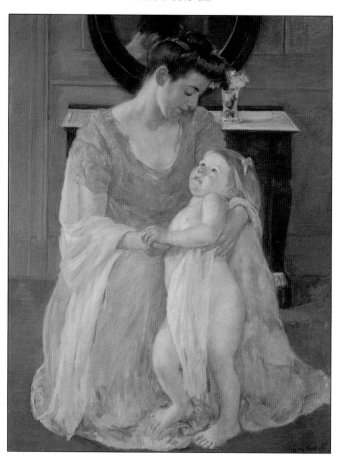

Plate 78

FRANCOISE IN GREEN, SEWING

1908–09, Montgomery Museum of Fine Arts, Montgomery, Alabama
81.28 x 65.41 cm

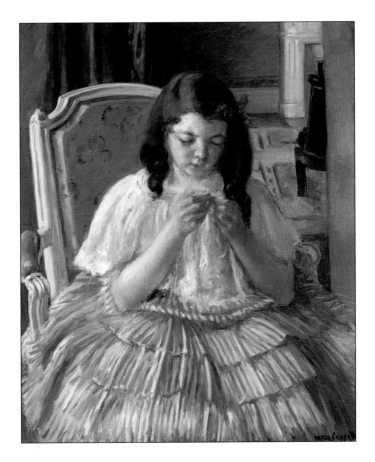

Plate 79

AUGUSTE READING TO HER DAUGHTER

1910, Private Collection
Dimensions unknown

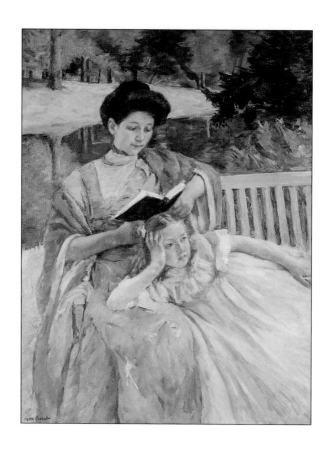

Plate 80

CHARLES DIKRAN KELEKIAN
1910, The Walters Art Museum, Baltimore
65.4 x 54 cm

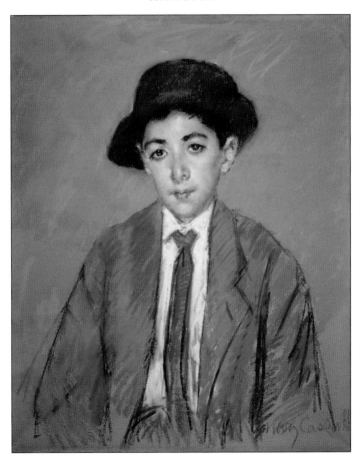

Plate 81

MOTHER AND CHILD

1914, The Metropolitan Museum of Art, New York City
81.3 x 65.1 cm

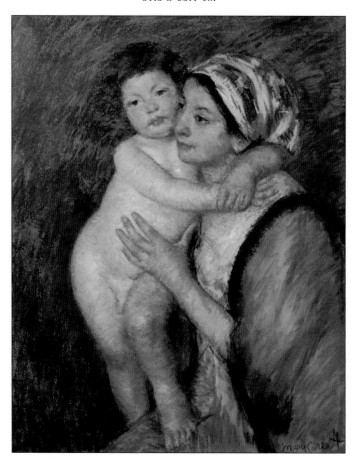

Plate 82

YOUNG WOMAN IN GREEN, OUTDOORS IN THE SUN

c. 1914, Worcester Art Museum, Worcester, Massachusetts
54.9 x 46 cm

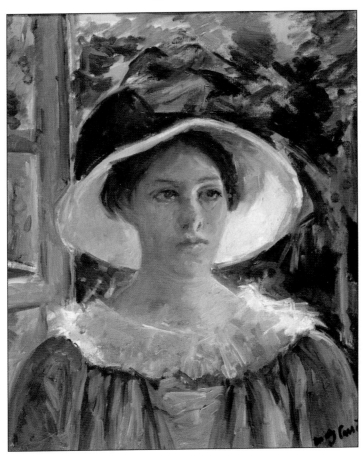

INDEX